Edward Burne-Jones

The Flower Book

With an essay by
Gabriele Uerscheln

Benedikt Taschen

Front cover:
Edward Burne-Jones: XI. Key of Spring
(cf. p. 39)

Back cover:
Edward Burne-Jones: XVIII. Golden Shower
(cf. p. 53)

Front flap:
Index of the English botanical names of the plants
which inspired Burne-Jones' allegorical flower pictures
(cf. p. 17)

Back flap / page 2:
Edward Burne-Jones (left) and William Morris
in the garden of The Grange,
Burne-Jones' Fulham home, c. 1890.
Original photograph by Frederick Hollyer.
Courtesy William Morris Gallery, London

Page 5:
Edward Burne-Jones: XXVII. Black Archangel
(detail; cf. p. 70)

The 38 flower pictures in this book are all taken
from the 14th copy of *The Flower Book*,
which is located in the collection of the Clemens-Sels-Museum,
Neuss (provenance: the library of the Duke of Kent).

© 1999 Benedikt Taschen Verlag GmbH
Hohenzollernring 53, D–50672 Köln
Editor: Angelika Muthesius, Cologne
Translation: Karen Williams, Low Barns
Photographs: Walter Klein, Düsseldorf

Printed in Portugal
ISBN 3–8228–7037–4
GB

I mean by a picture a beautiful romantic dream of something
that never was, never will be – in a light better than any light
that ever shone – in a land no one can define or remember,
only desire – and the forms divinely beautiful.
Edward Burne-Jones

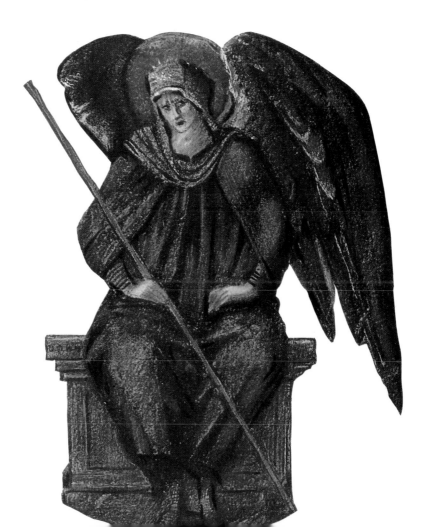

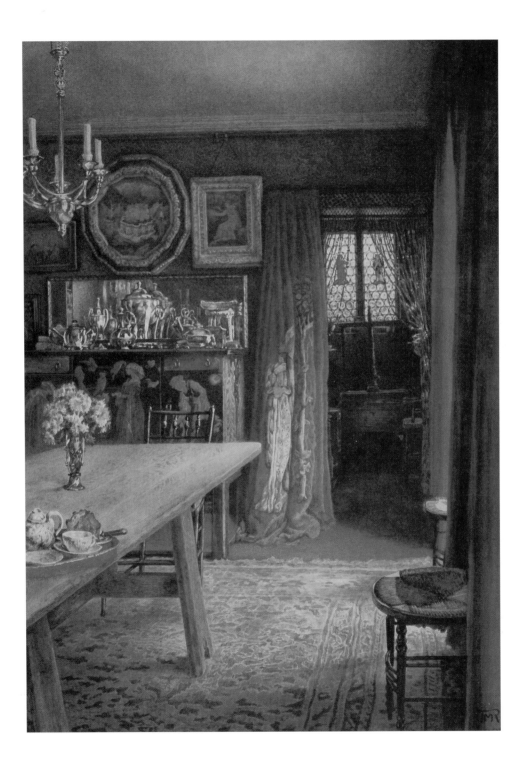

"The Flower Book" by Edward Burne-Jones

Edward Burne-Jones, a frail young man with artistic ambitions, discovered his love of a life of monastic seclusion on a visit to the Cistercian monastery of Mount St Bernard at the age of seventeen, while on holiday in the Leicestershire countryside. It was 1850. Two years earlier, Karl Marx had published his *Communist Party Manifesto*. Burne-Jones did not know Marx's writings; instead, he viewed the growing misery in his home city of Birmingham from a moral angle. While those benefitting from the advent of industrial mass production sang its praises, he rejected what he saw as a rising wave of materialism.

Burne-Jones displayed only a minor interest in contemporary literature. 1848 saw the publication of William Thackeray's *Vanity Fair*, an exposé of the two-faced morality of Victorian England. This was followed in 1850 by Charles Dickens' *David Copperfield*. Whether Burne-Jones was more interested in the scientific discoveries and inventions of his day is a question on which his biographers remain silent.

In the dawning industrial age it would become Burne-Jones' destiny to cast a "counter-spell" of beauty in a world which had lost its magic. He was still unaware that seven artists, who in 1848 had formed the Pre-Raphaelite Brotherhood and whose works were currently the objects of scathing criticism in distant London, would exert a decisive influence over his own artistic career.

When Edward Burne-Jones met the aesthete Dante Gabriel Rossetti in 1855, the latter's dream of a reform of the arts had been all but shattered by the reality of the art establishment in Victorian England. Rossetti, alongside William Holman Hunt and John Everett Millais, was one of the leaders of the Pre-Raphaelite Brotherhood. Although all the members had agreed to the principle of secrecy, it was not long before the group's identity was discovered. The Brotherhood developed into a movement which attracted considerable public attention, especially in London. The

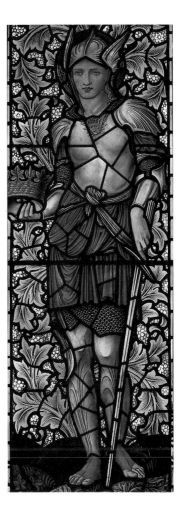

PAGE 6:

Anonymous copy of a painting by Thomas Mathew Rooke, one of Burne-Jones' assistants. It shows the dining room at The Grange, Burne-Jones' Fulham home. Courtesy Bateman

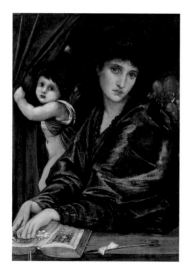

"Pre-Raphaelite" in the Brotherhood's name encapsulated its programme: the rejection of the academic, classicist conventions taught at tradition-bound schools of art – the Royal Academy being a prime example. They demanded a comprehensive overhaul of anecdotal and idyll painting, which in the opinion of the Pre-Raphaelites was sentimental and full of false emotions and had contributed to the decline of English art. The young men wished to place themselves entirely at the service of Truth and Beauty in art, as the early Italian masters before Raphael had also sought to do. This was by no means to exclude criticism of the social ills resulting from the spread of industrialization in their own times, however.

On the Continent, motives similar to those of the Pre-Raphaelites had earlier led a group of young French and German artists to form the "Lukasbund" (Brotherhood of St Luke), which was headed by Friedrich Overbeck and Franz Pforr. In 1809 the group – more commonly known as the Nazarenes – moved from Vienna to Rome. Here, in the seclusion of the Franciscan monastery of San Isidoro, they sought to give expression in their pictures to their veneration for Quattrocento Italian and medieval German art. Their religious commitment was reflected even in their hairstyles: inspired by a self-portrait by Albrecht Dürer, they wore their hair long. The imitation of Christ to which the Nazarenes aspired was not something shared by the Pre-Raphaelites, however, even though many of their works take religious subjects as their theme.

Dante Gabriel Rossetti, born in London in 1828 as the artistically gifted son of Italian emigrants, was interested less in religion than in literature. Indeed, such were his literary talents that, at the age of 20, he was still in two minds as to whether he should become a poet or a painter. It was only when the poet and art critic Leigh Hunt pointed out how difficult it was to make a living from writing that he finally chose a career as an artist.

As a Pre-Raphaelite who, true to his understanding of artistic practice in the Middle Ages, wanted to remove the personality element from his painting, Rossetti – like the other members of the Brotherhood – signed his early works with the letters "P.R.B." (Pre-Raphaelite Brotherhood). When, in 1849, the Pre-Raphaelites took part in a public exhibition for the first time as a group, Rossetti

showed his large-format *The Girlhood of Mary Virgin*. The favourable response which initially greeted the works by the members of the group rapidly turned to noisy outrage when the press deciphered the meaning of the initials "P.R.B." which they bore. Rossetti, Holman Hunt and their friends were reviled as a group of upstarts who had sullied the name of one of the greatest artists of all time – Raphael.

The vicious offensive launched against the "newcomers" by the established art press led to tensions with the group. While Millais and Holman Hunt refused to be daunted and continued to submit their paintings to subsequent Royal Academy exhibitions, Rossetti vowed never to show his work in public again. Things changed, however, when in 1851 the influential art critic and theoretician John Ruskin defended the Pre-Raphaelites in two open letters to *The Times*. For the members of the Brotherhood, however, growing public recognition and the relative material prosperity which followed were not enough to prevent the gradual break-up of the group. It was not long before members were signing their works in their own names, and in 1854 they all went their separate ways.

It was at about this time that Edward Burne-Jones, a fervent admirer of Pre-Raphaelite art, was introduced to Dante Gabriel Rossetti. Their meeting fuelled a revival of the group's original aims. Perhaps Rossetti recognized in his younger colleague the same hopes and ideals that had once filled his own heart. He offered Burne-Jones tuition, employed him on his own commissions, and introduced him to John Ruskin.

Edward Burne-Jones became one of the most esteemed of the second-generation Pre-Raphaelites. Together with William Morris, with whom he had been friends since his student days at Oxford, he carried the ideals of the first generation a stage further. Pre-Raphaelite art continued to exert an important influence on the art scene both in England and continental Europe right up to the First World War. In Belgium and France, in particular, Fernand Khnopff and Gustave Moreau – the great lone wolves of Symbolism – attacked "trite" naturalism and mindless materialism in their paintings.

Sir Edward Burne-Jones – in the meantime a baronet – died in 1898 at the age of 65. His *Flower Book* only appeared seven years

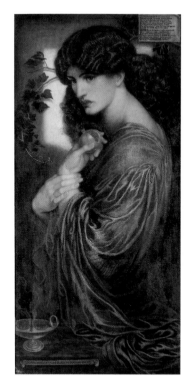

Dante Gabriel Rossetti:
Proserpina, 1877
Oil on canvas, 119.5 x 57.8 cm
Manchester Art Gallery,
on loan from the L.S. Lowry Collection

later, however, in 1905. It was published by his wife, Georgiana Burne-Jones, and printed in an edition of 300 copies – a normal size for editions around the turn of the century. *The Flower Book* comprises reproductions of 38 circular paintings, each 15.24 cm in diameter, accompanied by a preface by Georgiana Burne-Jones, subtitles to the individual pictures and four facsimile pages of lists of flowers in Burne-Jones' own hand.

The fact that *The Flower Book* only appeared after Burne-Jones' death is explained by its nature, which resembles that of a diary of the artist's secret yearnings. For Georgiana Burne-Jones, these flower pictures are an intense reflection of her husband's personality. In her view, they are "so intimately characteristic of the painter that I have sometimes thought this book contains a fuller expression of himself than exists elsewhere in his work".[1] This may sound somewhat surprising at first, particularly considering the rather hackneyed genre of flower books in fashion at that time. Such flower books typically assign clichéd meanings to specific flowers according to a standard formula. Thus the rose regularly symbolizes true love, while the forget-me-not signals hope of a rendezvous and the carnation testifies to erotic desire. The secret longings encoded in flowers in these refined but sentimentalized manuals were of no interest to Burne-Jones, however, precisely because they were too easy to decipher. In his own *Flower Book*, by contrast, the reader will look in vain for a familiar representation of a flower.

Lines in a letter which Burne-Jones wrote to a friend offer a vital key to understanding *The Flower Book*. The artist asks his friend to send him as many names of flowers as he can, since "it is not one in ten that I can use". It is of course possible, he admits, to paint something to illustrate every name, but as he continues: "I want the name and the picture to be one soul together, and indissoluble, as if they could not exist apart."[2] In a much earlier letter of 1854, when he was still a young theology student at Oxford, Burne-Jones had written of his sadness that humankind was debarred from living in paradisiacal oneness with nature. His vision of a "golden age" would accompany the artist throughout his life: "I get frightened of indulging now in dreams, so vivid that they seem recollections rather than imaginations, but they seldom last

Edward Burne-Jones' hand-written list of flower names. One of four facsimile pages from The Flower Book.

more than half-an-hour; and the sound of earthly bells in the distance, and presently the wreathing of steam upon the trees where the railway runs, called me back to the years I cannot convince myself I am living in."[3]

Burne-Jones began work on his flower pictures in 1882, at the age of 49. The majority were painted in Rottingdean, a small seaside town in Sussex where he liked to spend the summer. The artist suffered increasing bouts of ill health as he grew older, which obliged him to take rests from his work on large compositions. It was during such periods in Rottingdean, when he was confined to his sick bed, that he was able to devote himself to his smaller-scale flower pictures. Using a mixture of pastels and watercolours – materials which had previously only served him for quick sketches and preliminary studies – he produced intimate pictures in which he allowed his imagination full rein.

Burne-Jones would take the traditional name of a flower and transport it into his own inner world, peopled with biblical characters and the heroes of Arthurian and classical legend who were ardently admired in the England of the second half of the 19th century. There are figures, too, of pure fantasy. It is clear from even a fleeting glance at the pictures that, however fascinating it might be to try to identify the flower behind each name, the artist's intentions lie elsewhere. Burne-Jones devoted particular attention to less common names which were threatening to fade into oblivion, and the more mysterious and fairytale-like the sound of the name, the more it fired his imagination. Burne-Jones sought to draw his viewers beyond the everyday level of concrete images, where the name of a flower instantly conjures up a mental picture of a specific plant. Thus he concentrated upon flower names which were not necessarily familiar in his own day and whose symbolic power was not yet exhausted. Whether the artist himself even knew what flower was actually meant by all of the names he selected is a question which remains unanswered today. He was fascinated first and foremost by the associative powers of these names within his fantasy. It is no longer possible to identify the individual plants in all cases: even at the time when Burne-Jones painted his flower pictures, the large majority of the names featured in the artist's lists were only familiar and in usage in rural communities.

Cover of The Flower Book, which contains 38 allegorical flower paintings. Clemens-Sels-Museum, Neuss

THE LAPSE OF THE YEAR

SPRING am I, too soft of heart
Much to speak ere I depart:
Ask the summer-tide to prove
The abundance of my love.

SUMMER looked for long am I
Much shall change or ere I die
Prithee take it not amiss
Though I weary thee with bliss!

Laden AUTUMN here I stand,
Weak of heart and worn of hand;
Speak the word that sets me free,
Nought but rest seems good to me.

Ah, shall WINTER mend your case?
Set your teeth the wind to face,
Beat the snow down, tread the frost,
All is gained when all is lost.

With the exception of *Arbor Tristis* (XXVIII; p. 73), which shows the foot of the Cross of Golgotha and whose stylistic characteristics appear to anticipate Pittura Metafisica, all the flower pictures are figure paintings. The flower name *Key of Spring* (XI; p. 39), for example, proves the inspiration for a delicate figure who, as the artist explains in the subtitle, is "unlocking" a tree with a key "that the sap may rise". Here we are dealing with a case of free association, with the figure of Spring a pure invention of the artist's imagination. In other pictures in *The Flower Book*, however, Burne-Jones associated the names of flowers with well-known characters and motifs from our cultural heritage.

On several occasions the artist takes up themes which he had already elaborated in large-format works, or would subsequently re-interpret in later works. In this way, his flower pictures and larger paintings served as mutual sources of inspiration. Like his large compositions, his flower pictures were also to be entirely indebted to "the sophistication in grace and elegance to which the Gothic aesthetic aspired".[4] Not all of them are worked right through to the last detail, but this very lack of polish results in an impression of spontaneity and speed of execution which is missing from Burne-Jones' bigger paintings, many of which took years to complete.

Each of the 38 circular paintings points in its own way to the idea of the closed circle and the sphere as symbols of the cosmos. In her preface to *The Flower Book*, Georgiana Burne-Jones describes them as "a kind of magic mirror in which the vision appears". In this context, *Astrologia*, which Burne-Jones painted in 1865, offers an illuminating parallel: a woman, portrayed in the Venetian manner, is gazing in fascination into a crystal ball. In *The Flower Book*, similarly, the viewer's eye is drawn directly into the picture as into a crystal ball in which the artist's visions appear – a process facilitated by the lack of all barriers in the pictorial foreground. As a rule, the circular format of the flower pictures is taken up within the composition, with the artist employing curving lines to define the various pictorial planes. Thus in some cases the ground appears to arch forwards towards the viewer, while in others the eye is drawn far into the depths, depending on the manner in which these compositional lines are curved. In *Golden*

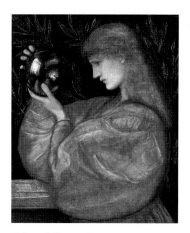

Edward Burne-Jones:
Astrologia, 1865
Gouache, 54.5 x 46.5 cm
Thos. Agnew and Sons Ltd.,
London

PAGE 12:
A page from The Lapse of the
Year, a book of poems by William
Morris, 1870
The Victoria and Albert Museum,
London

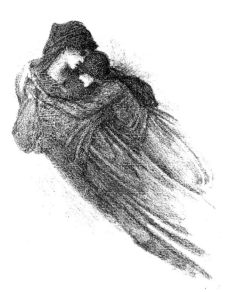

Edward Burne-Jones:
Paolo and Francesca, from the
artist's sketchbook,
begun 1885
The British Museum, London

Greeting (XVII; p.51), the artist goes so far as to create two "land-scapes" – one heavenly and one earthly – which he juxtaposes like segments of a circle within the one picture. The upper segment thereby seems to be thrusting into the lower, creating an impression of two enlarged, intersecting disks from the different hemispheres of the cosmos. Burne-Jones here illustrates a dimension in which the laws of space and time, as constructs of the mind, are lifted. – The circular format of the flower pictures is also emphasized by the figures, whether nestling their bodies against the rounded edge of the picture or taking up its curving lines in their poses. Virtually every picture is a spark to the imagination – especially when considered as part of a cycle, which is how the artist wanted *The Flower Book* to be understood. Thus each picture appears before the viewer only to yield to the vision of the next.

The majority of these flower pictures take up themes which fall fully into the Romantic tradition. The figure of King Arthur, in particular, had fascinated Burne-Jones ever since his student days in Oxford, and *Witches' Tree* (XV; p.47) was inspired by Sir Thomas Malory's treatment of the Arthurian legends in *Le Morte Darthur* (c. 1470). Here the artist illustrates the theme of the endless struggle between the sexes in an episode between Merlin, King Arthur's legendary wizard, and his beautiful apprentice Nimue. *Witches' Tree* also draws upon the ancient notion of sleep as rest during an intervening period of wait, a theme which reappears in the sleeping figure of King Arthur in *Meadow Sweet* (XXXV; p.87). In *Love in a Tangle* (XIV; p.45), Burne-Jones takes a motif from the ballad of Fair Rosamond, the "fatal mistress" of Henry II who was poisoned by Queen Eleanor. Historical background aside, by bringing together two potent images (the tale of Fair Rosamond and the maze at Hampton Court) the artist illustrates the tragic tangles into which people are led by the power of Eros and Thanatos. The labyrinth was originally a symbol of the harmonious union of these two forces.

Another, psychological variation of this theme is found in *With the Wind* (XXII; p.61). The artist's imagination responded to the name of this flower with a portrayal of Paolo and Francesca, the famous lovers who appear in the first part of *The Divine Comedy* by Dante Alighieri (1265 – 1321). Their love forbidden by social

convention (they were brother-in-law and sister-in-law), the artist sees them united beyond the bounds of time and space. In *With the Wind*, Burne-Jones thus continues in his own way the tradition of the artistic allegory of the spiritual union of opposites: for him, true union can only be achieved in the celestial sphere.

Burne-Jones' flower pictures are more than simply the mimetic representation of his personal powers of fancy; they testify to his own ideal that "the name and the picture [should] be one soul together". *The Flower Book* unfolds before the viewer in a cycle of paintings which reveal the inexhaustible wealth of the artist's imagination. They invite us to follow Burne-Jones' creative process as he draws his themes from a rich diversity of cultural sources and presents them in a new context. "Wide as is their scope," however, as Georgiana Burne-Jones observes in her preface to *The Flower Book*, the flower pictures are not be separated, because "one spirit, that of pure fantasy, unites them."

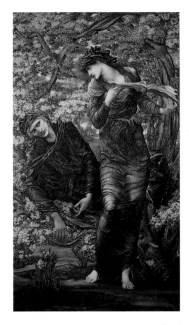

Edward Burne-Jones:
The Beguiling of Merlin, 1877
Oil on canvas, 186. 2 x 110. 5 cm
Lady Lever Art Gallery, Port
Sunlight

1 Cf. the preface by Georgiana Burne-Jones to *The Flower Book*.
2 Quoted from Martin Harrison and Bill Waters: Burne-Jones, London 1973, p. 146 f.
3 Ibid., p. 16
4 Cf. Rosario Assunto: Die Theorie des Schönen im Mittelalter, (first German edition, Cologne 1963) Cologne 1982, p. 110

In the following cases it has been possible to establish the English and Latin botanical names of the plants which inspired Burne-Jones' allegorical flower pictures:

I. Love in a Mist: fennel-flower
(Nigella damascena)

III. Jacob's Ladder: Greek valerian
(Polemonium caeruleum)

IV. Traveller's Joy: clematis (Clematis vitelba)

V. Rose of Heaven: campion
(Lychnis coeli-rosa)

VI. Flower of God: flower of Jove
(Lychnis flos-jovis) or bird's-foot trefoil
(Lotus corniculatus)

VII. Golden Cup: probably marsh marigold
(Caltha palustris)

VIII. Adder's Tongue: crowfoot
(Ranunculus ophioglossi folius)

IX. Golden Gate: herb Robert
(Geranium robertianum)

X. Venus' Looking Glass: Venus' looking-glass
(Legousia hybrida)

XII. Ladder of Heaven: lily of the valley
(Convallaria majalis)

XIV. Love in a Tangle: biting stonecrop
(Sedum acre)

XV. Witches' Tree: probably rowan-berry
(Sorbus aucuparia)

XVIII. Golden Shower: pudding-pipe tree
(Cassia fistula)

XIX. Flame Heath: heather (Erica)

XX. Star of Bethlehem: star-of-Bethlehem
(Ornithogalum umbellatum)

XXI. Morning Glories: morning-glory
(Ipomoea umbellatum)

XXII. With the Wind: probably honey-suckle (Lonicera periclymenum)

XXVI. Marvel of the World: horehound
(Marrubium vulgare)

XXVII. Black Archangel: red dead-nettle
(Lamium purpureum)

XXXI. Welcome to the House: spurge
(Euphorbia cyparissias) or houseleek
(Sempervivum tectorum)

XXXIII. Most bitter Moonseed: moonseed
(Menispermum)

XXXV. Meadow Sweet: meadow-sweet
(Filipendula ulmaria)

XXXVII. Fire Tree: probably pyracanth
(Pyracantha)

XXXVIII. Day and Night: daisy
(Bellis perennis)

INDEX.

I. Love in a Mist

A mist which does not rise from the earth but is made of heaven's blue, swirls round and round the struggling figure of a winged-man, who is Love himself, baffled and blinded by its folds ❖

Burne-Jones only gave the first of his thirty-eight flower pictures, posthumously published in 1905, such a lengthy subtitle ❖

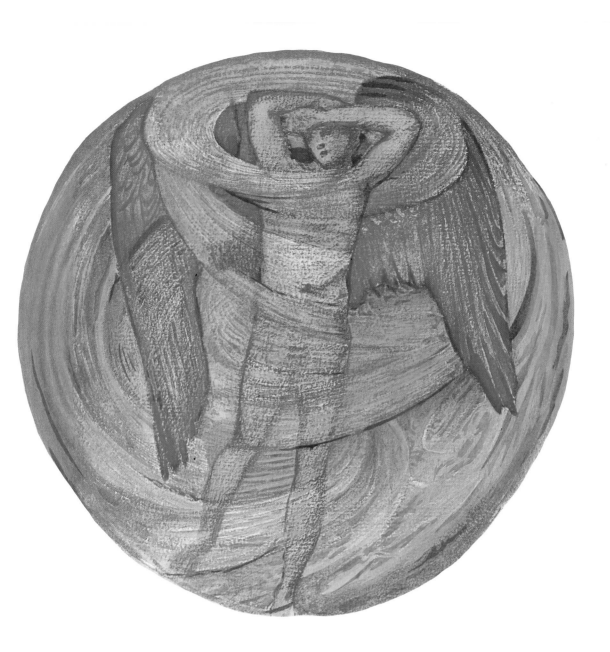

II. Golden Thread

The clue that Ariadne gave to Theseus, to help him through the Cretan Labyrinth ❖

In October 1860 Edward Burne-Jones and Dante Gabriel Rossetti paid a visit to Hampton Court, plunging themselves into its famous maze with a romantic shiver of fear. The labyrinth was a theme that fascinated Burne-Jones, as many of his works reveal: in the flower picture *Love in a Tangle* (XIV), for example, it is linked with the medieval tale of Fair Rosamond. In *Golden Thread*, the artist draws upon the ancient Greek legend of Theseus and the Minotaur, a mythical monster who dwelt at the heart of a labyrinth on the island of Crete and who fed upon a regular tribute of sacrificial victims. With the aid of Ariadne's "clue" – a ball of golden thread which he unwinds as he goes, and which will later enable him to retrace his steps to the entrance – the Greek hero enters the dark labyrinth in order to slay the Minotaur ❖

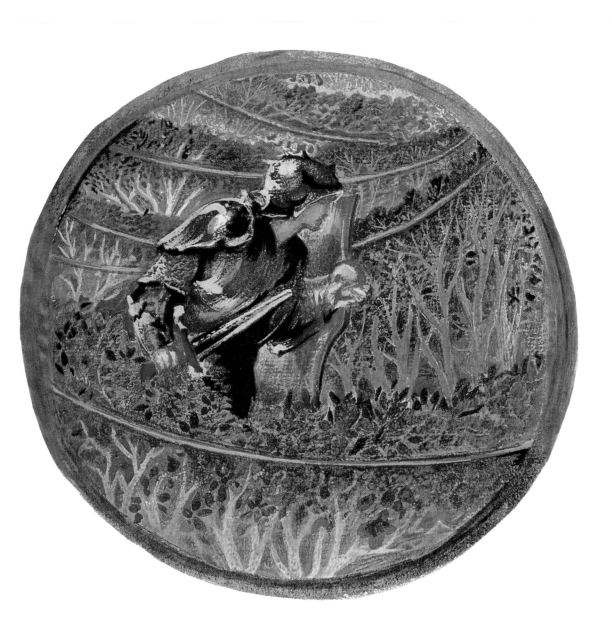

III. Jacob's Ladder

These are Angels returning to heaven ❖

Curiosity about the beauty of the daughters of earth had disastrous consequences for some angels. Rendered wingless, they were banished to earth to do penance. Finally redeemed, the angels are here seen returning to the heavenly sphere by climbing a ladder which reaches from the earth, through the firmament, and up to the radiant seat of the Divine ❖

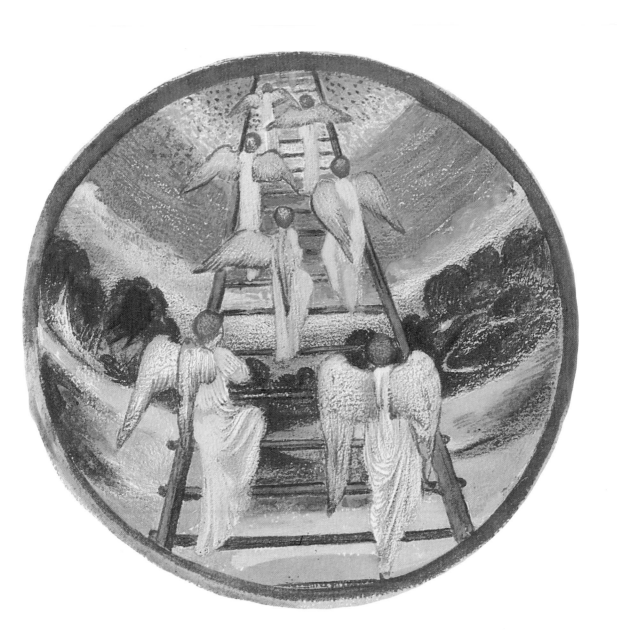

23

IV. Traveller's Joy

The Three Kings first see from afar the Virgin and Child ❖

The flower picture *Traveller's Joy* shows not the actual arrival of the Three
Kings at their destination, but the point at which they round the final corner
and come into sight of what they have been hoping to find – the prophesied
birth of the Holy Child. Here, a flower name has inspired a nativity scene in
which Burne-Jones captures the joyous moment at which hope of the new
becomes certainty ❖

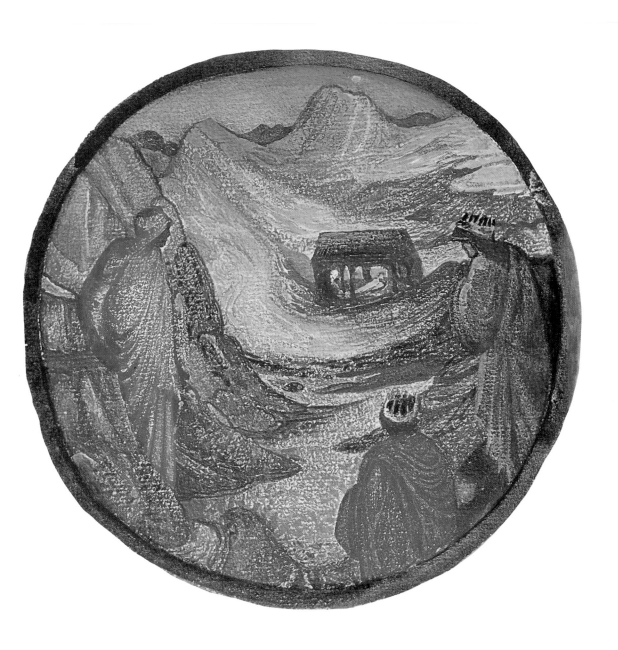

V. Rose of Heaven

*V*enus and her doves amongst the stars ❖

The obvious debt which this flower picture owes to Sandro Botticelli's Birth of Venus reflects Burne-Jones' admiration for the earlier Renaissance master. The subject of Rose of Heaven differs from that of Botticelli's much larger canvas, however. The Pre-Raphaelite Burne-Jones sees Venus in the heavens, surrounded by stars and accompanied along her path by doves. The attribute of the mirror reveals her as the goddess of beauty, the Rose of Heaven ❖

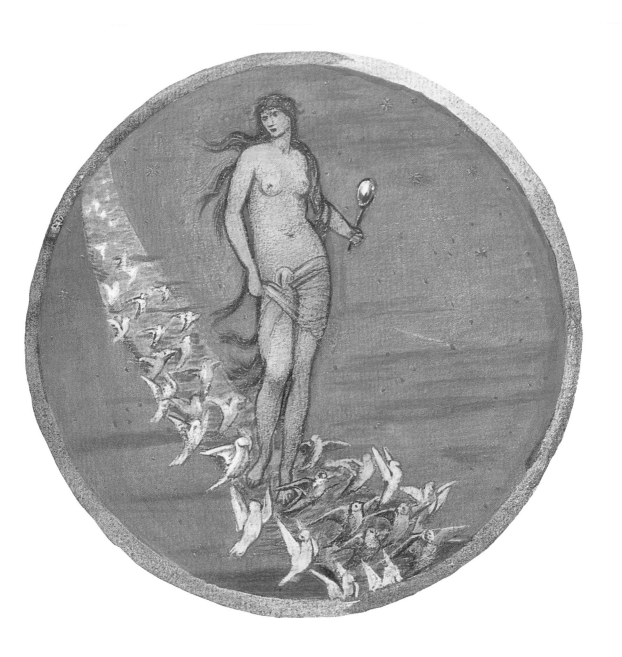

VI. Flower of God

The Annunciation in a cornfield ❖

In this version of the Annunciation, the Archangel Gabriel appears before the
Virgin Mary in the unusual setting of a cornfield. The golden stalks of wheat
bow as if in reverence to make way for the two figures. With his left hand, the
hovering messenger of God holds out a Madonna lily, which Mary, drawing
back slightly in fear and awe, takes in her right hand. The lily – a symbol of
purity and innocence in Christian iconography – thus becomes the link
connecting the angel and Mary ❖

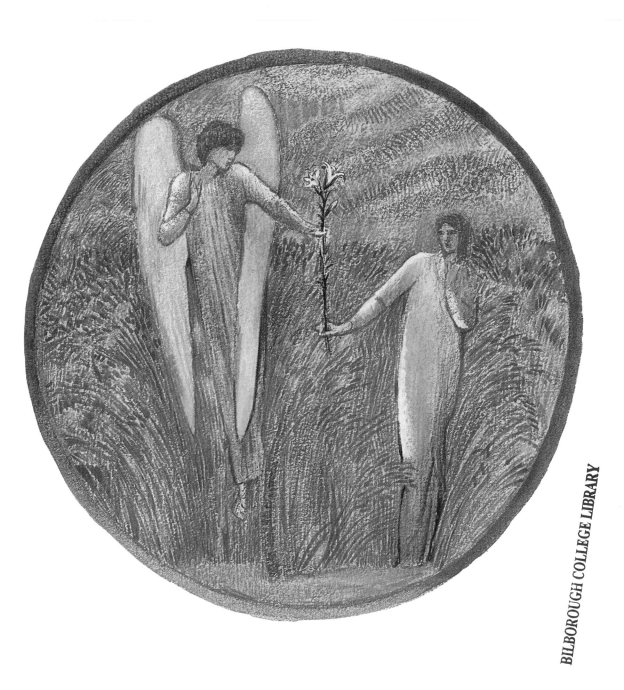

29

VII. Golden Cup

An Angel carrying the San Graal past sleeping knights in a wood ❖

Burne-Jones was fascinated by the legends of the Knights of the Round Table from his student days onwards. The flower name *Golden Cup* thus called to his mind an image of the Holy Grail, the chalice which, according to medieval tradition, was used to catch Christ's blood during his crucifixion. Anyone who set eyes on the Holy Grail, it was believed, would attain mystical enlightenment. In *Golden Cup*, an angel bears the Holy Grail unseen past a band of sleeping knights, who thus miss a precious chance to fulfil their quest ❖

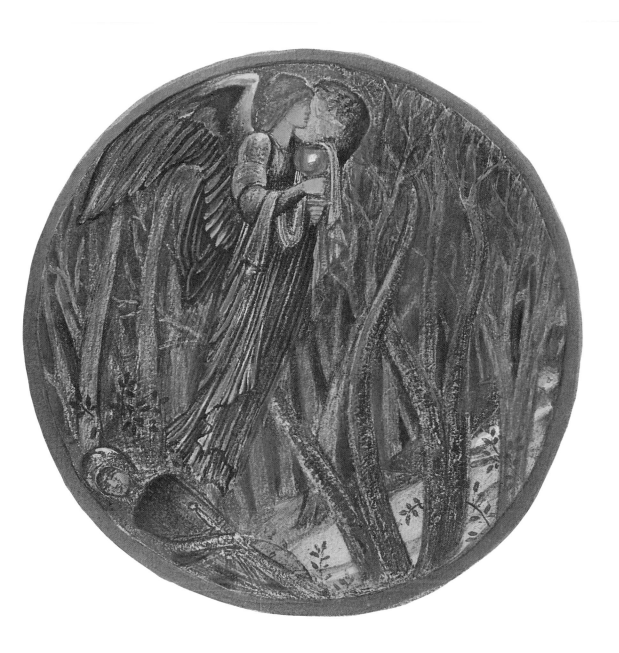

31

VIII. Adder's Tongue

The Temptation ❖

The figures of Adam and Eve are set against the dense foliage of an impenetrable, darkly foreboding forest of fruit-laden trees. Temptation, in the form of a woman, rises from one of the tree-trunks, holding out a fruit in her right hand. In contrast to the dark figure of the Temptress, the pale bodies of Adam and Eve lend them a sense of innocence and vulnerability in their nakedness. Burne-Jones portrays Adam and Eve at the moment of temptation in which they are still united; division, however, is already threatened ❖

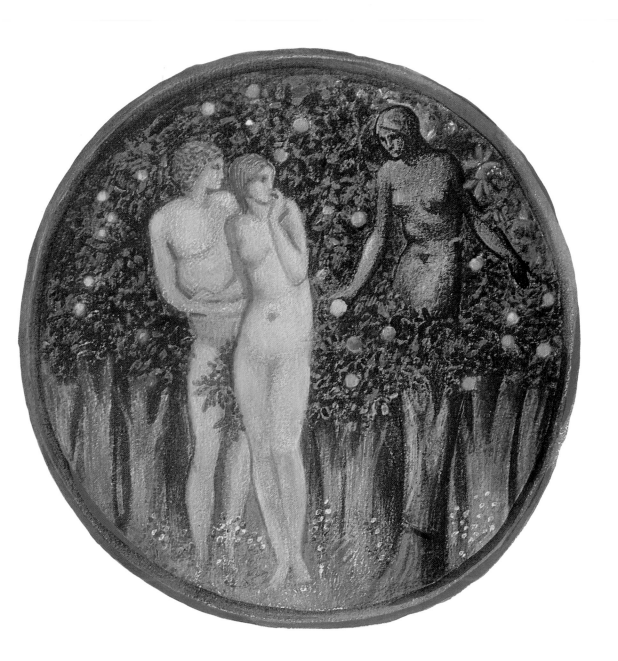

33

IX. Golden Gate

Angels bringing out the Sun ❖

In Golden Gate, Burne-Jones takes up the theme of the days of Creation. This was something he had already treated in The Days of Creation (1870–76), a pictorial cycle in which angels carry large crystal balls showing what each day of creation will bring. Adopting a more modest framework, Golden Gate depicts an angel stepping from the celestial to the earthly sphere and, as a medium of God, bringing the sun to earth ❖

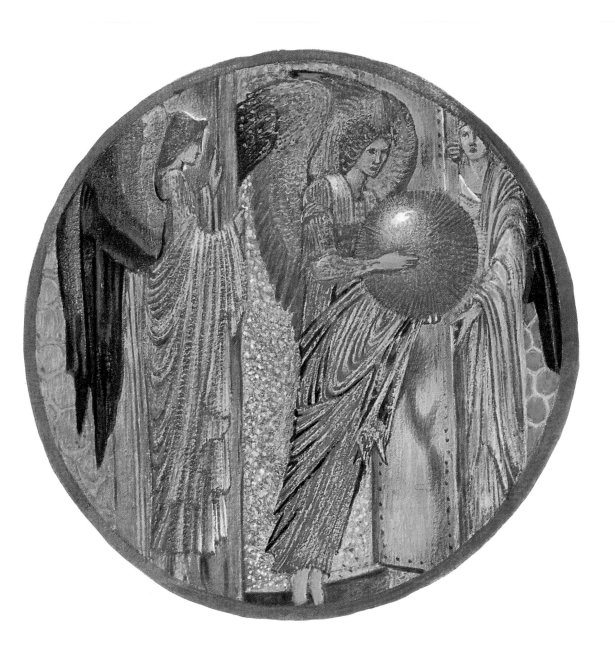

X. Venus' Looking Glass

The full moon is made her mirror ❖

Venus, in classical mythology the goddess of love and beauty, dominates the composition. Her gaze is directed across the celestial landscape towards the full moon beyond. Gleaming in all its roundness, the moon is like a mirror glass, flooding the entire scene with light. Somnambulent worlds are given shape in the figure of Venus as she contemplates the moon; she becomes the artistic projection of a diffuse longing ❖

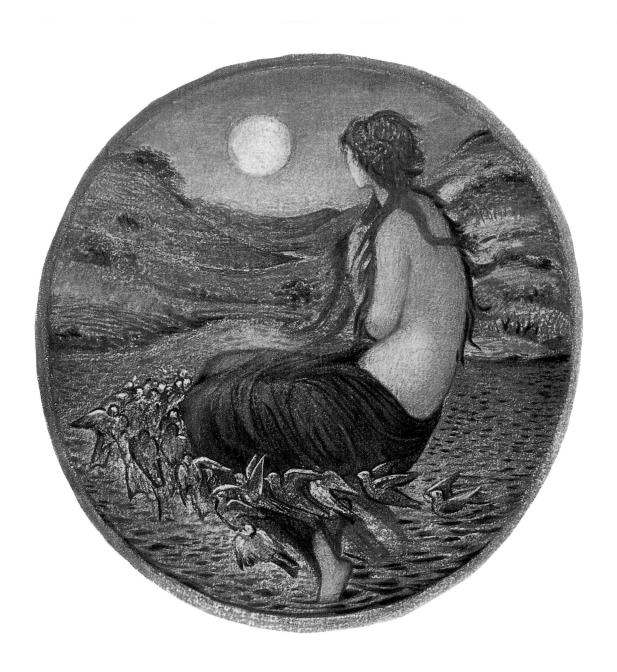

XI. Key of Spring

A Figure unlocking a tree that the sap may rise ❖

While certain flower names prompted Burne-Jones to think of characters from literature, the figure personifying the creative force of spring in *Key of Spring* is born directly of the artist's imagination. Amidst a brown landscape dotted with leafless trees, with the sea visible through the hills behind, the delicate, blue-clad figure of winged Spring flies from tree to tree, key in hand, arousing nature from its winter sleep ❖

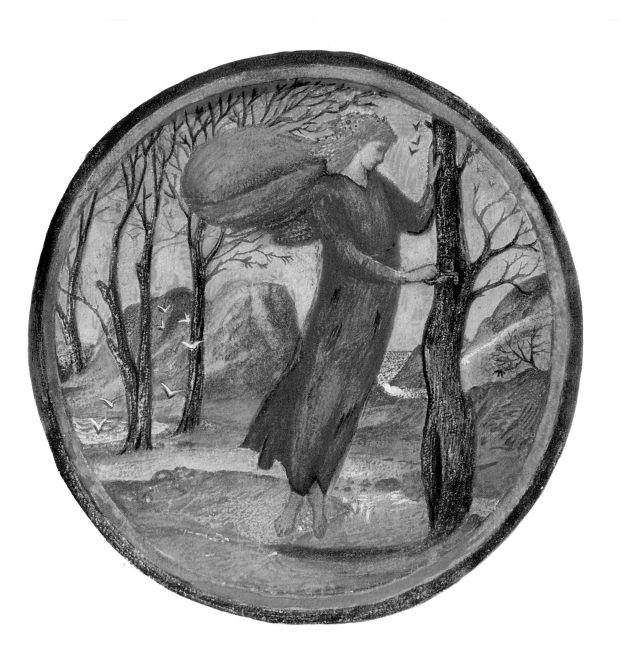

39

XII. Ladder of Heaven

A Soul climbing the side of a rainbow ❖

Here Burne-Jones associates the flower name *Ladder of Heaven* with the aftermath of the Flood. Thus the rainbow represents a token of the covenant between God and man, while the olive branch repesents a sign of peace. Whereas, in the Old Testament story, the olive branch is borne by a dove, it is here being carried up the Ladder of Heaven by a winged figure. Freed from all earthly burdens, the Soul is able to tread the rainbow as a path to a heavenly existence ❖

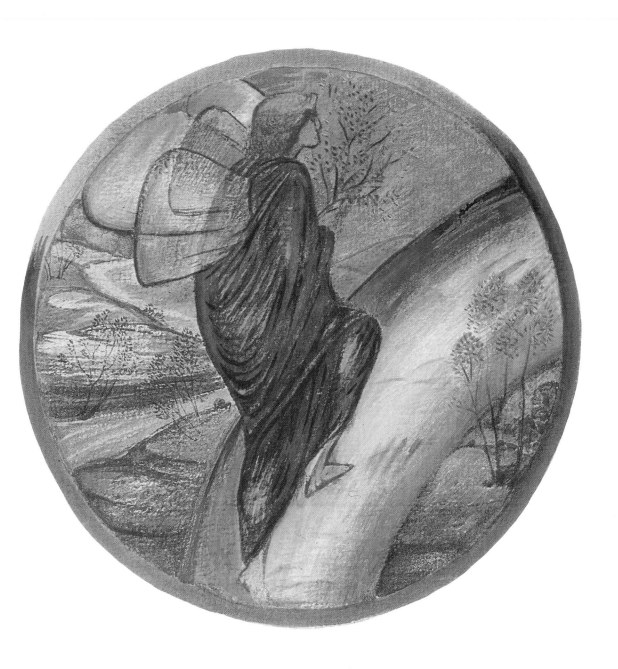

XIII. Comes he not?

A girl watching for her lover from the top of a tower ❖

This flower name translates in the artist's mind into an image of longing, expressed in the figure of a woman watching for her beloved. While she waits in enforced passivity, her lover must defend himself actively in the world. The motif of the waiting woman was taken up in countless variations by Burne-Jones and his Pre-Raphaelite friends. This pictorial distinction between the roles of the two sexes – a distinction which permeates the entire history of western culture – evidently reflected the situation in Victorian England. An early example of the theme is found in the figure of Penelope in Homer's *Odyssey*: Penelope is extolled as the faithful wife who tends the house until her husband, Ulysses, returns victorious from his wanderings ❖

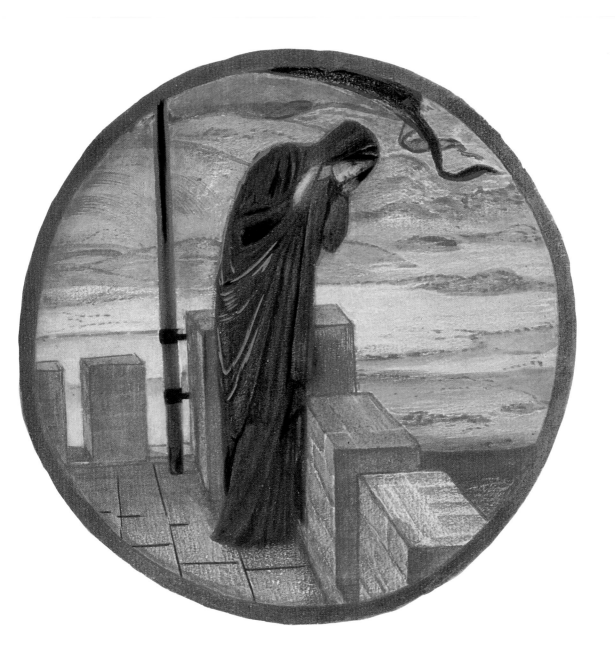

XIV. Love in a Tangle

Fair Rosamond in her labyrinth ❖

Hidden from the eyes of the world, Fair Rosamond, the mistress of Henry II, lived in a bower at the heart of a hedge labyrinth which the king had planted for her. Only she and her royal lover knew the way to the centre. The medieval ballads surrounding Fair Rosamond's story provided inspiration for numerous works by the Pre-Raphaelite painters. In *Love in a Tangle*, Burne-Jones fuses elements of these ancient ballads with the mysterious, secretive atmosphere of the maze at Hampton Court ❖

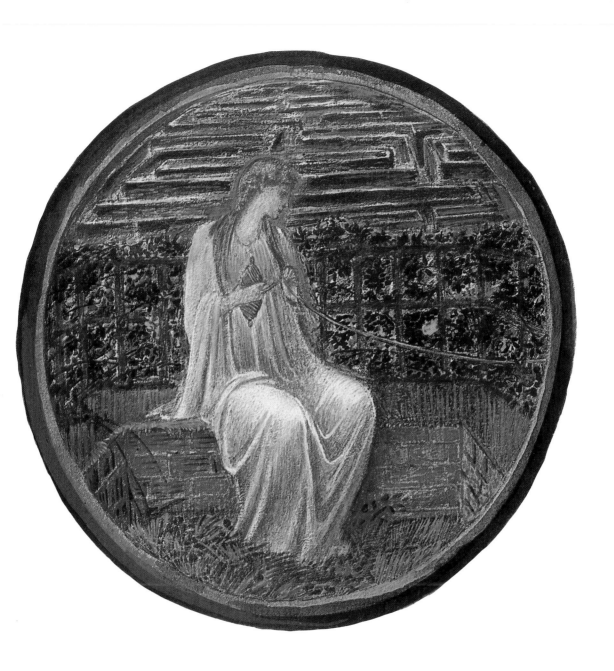

XV. Witches' Tree

Nimue beguiling Merlin with enchantment ❖

According to Celtic tradition, the enchanter Merlin was a master of secret
powers. As King Arthur's teacher and counsellor, the figure of Merlin
combines many aspects of the transition from Celtic natural religion to
western Christianity. Burne-Jones chooses to focus on the episode in Merlin's
life in which he is robbed of his powers: beguiled by his beautiful apprentice
Nimue, he is sunk into eternal sleep by the very skills which, grown foolish
with love, he taught her ❖

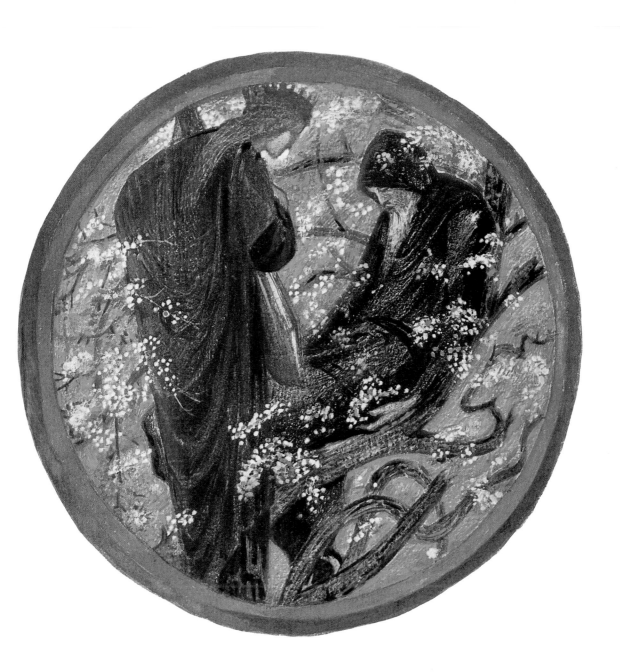

47

XVI. Grave of the Sea

A drowned man found by a mermaid ❖

Motifs from the picturesque seaside town of Rottingdean, where Burne-Jones devoted himself to his flower pictures, appear in many of his drawings. But it was the underwater world of the sea that sparked the most intensive flights of his imagination. He saw its mysterious depths filled with mermaids and other fabulous creatures. In *The Depths of the Sea*, a gouache of 1887, a water sprite tenderly draws a young man down into her realm, as if unaware that this will cause the death of her victim. In the present flower picture, a mermaid comes upon a young man who has already found his watery grave ❖

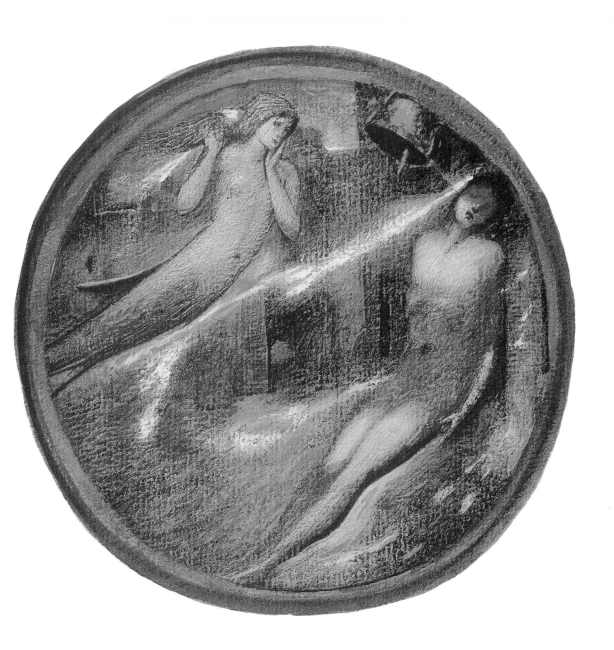

49

XVII. Golden Greeting

M eeting after death ❖

The heavenly and earthly spheres slice into the round flower picture like segments of circles from two different worlds. Across the line where they meet, a figure from this world reaches longingly towards a being in the world beyond. Once again, the artist associates a flower name with a motif of yearning. With the two figures bound to their separate spheres, such an embrace cannot take place in this life. It is only after death that the soul's longing to meet other souls will finally be fulfilled ❖

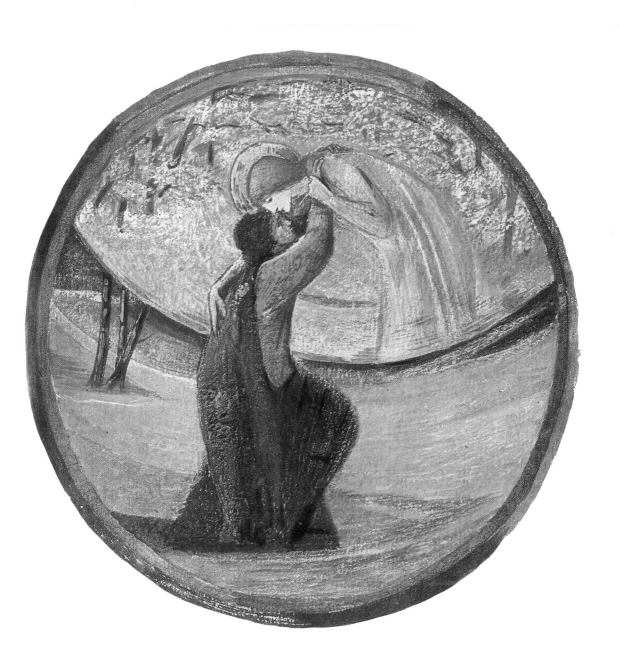

XVIII. Golden Shower

Danaë in the Brazen Tower ❖

In Greek legend, Danaë was the daughter of Acrisius, King of Argos. Having
being warned by the Delphic Oracle that he would die at the hands of his
future grandson, the King locked up his daughter in a tower of brass. His
precautions were in vain: Zeus, father of the gods, succeeded in gaining access
to Danaë by changing himself into a shower of gold, and she thus become the
mother of Perseus. Whereas interpretations by other artists frequently show
Danaë receiving the golden shower in a warm and homely interior,
Burne-Jones portrays the young woman imprisoned in the cold setting of a
room panelled with metal. The arrival of Zeus floods the room with gleaming
light ❖

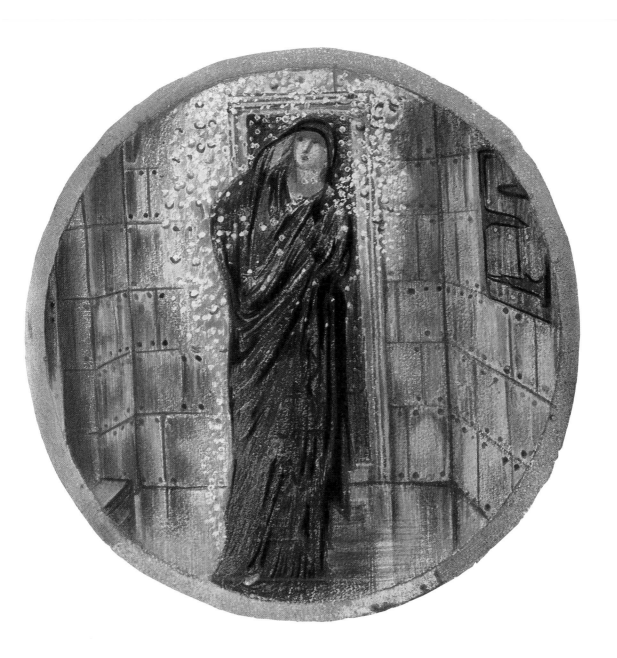

XIX. Flame Heath

Brynhild's Sleep ❖

As if exhausted after battle, the beautiful, armour-clad Brunhild rests amidst a ravaged landscape, strips of flame still flickering around her. In her sleep, she turns towards her shield and lance. *Flame Heath* has its source in the Nibelungenlied, in which Brunhild plays a central role. A queen as fair as she is proud, Brunhild will only give herself to a man of equally high worth. Her weak husband, Gunther, contrives with Siegfried to deceive her on her wedding night. Disguised, Siegfried wins her by strength in place of Gunther, and lays a sword at her side as a sign of her defeat ❖

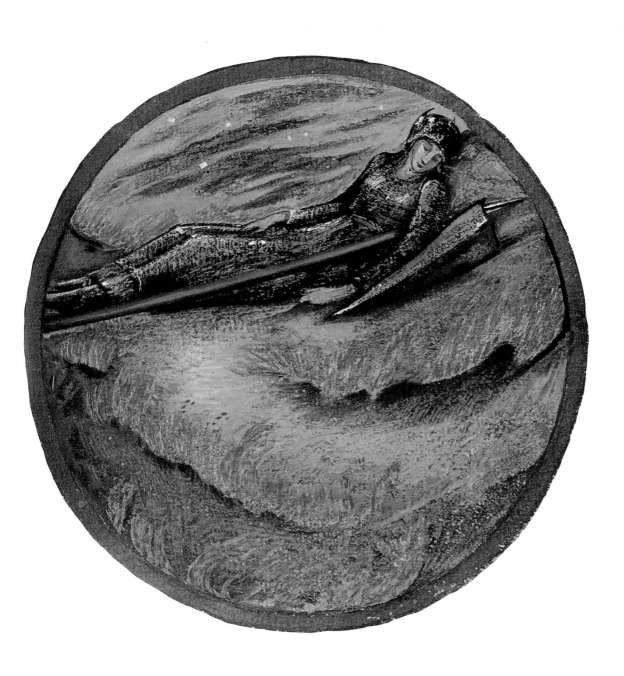

XX. Star of Bethlehem

The Angel leads the Wise Men by its light ❖

The Biblical story of the Three Wise Men and their search for the prophesied king had already provided the starting-point for *Traveller's Joy* (IV). In *Star of Bethlehem*, the figures of the Magi are almost lost in the rock-strewn landscape rising steeply behind. Approaching from different directions, they stop, as if wanting to reassure themselves that they are following the "right" guiding star. Together, the angel carrying the star in the foreground and the Three Kings form an unbroken circle, illustrating the biblical prophesy of completion. The profound nature of the scene is underlined by the symbolism of the colours: the yellow, blue and red of the Magi's robes represent the elements of earth, water and fire, while the white of the angel's raiment symbolizes the aetherial element of air ❖

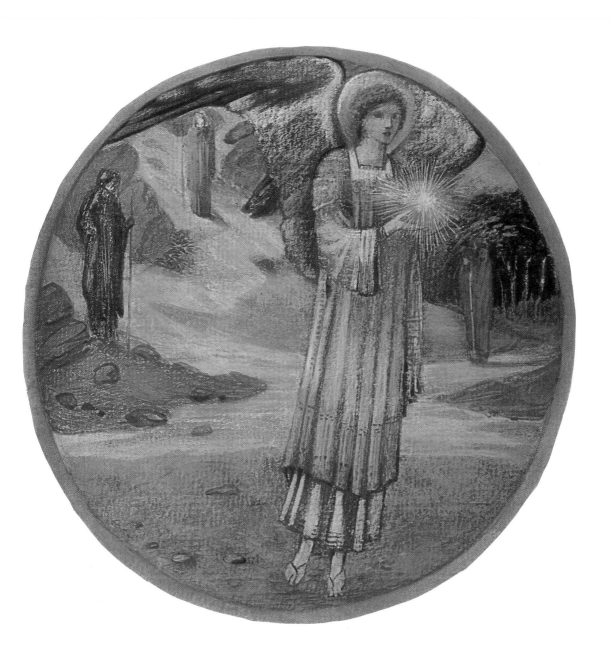

XXI. Morning Glories

Angels spreading out clouds at dawn ❖

Angels are hovering above a field drenched in golden light. They are spreading
out pink-tinged clouds, which cast their blue shadows onto the field below.
This field runs far into the depths of the picture, where its boundary line
curves upwards to meet the sky. The pale figures of the angels form a link
between the two spheres of brown earth and blue sky. Like *Key of Spring*
(XI), *Morning Glories* is another example of the way in which the artist liked
to personify events in nature. Burne-Jones' natural spaces are always peopled
with angels, fairies and other fairytale creatures ❖

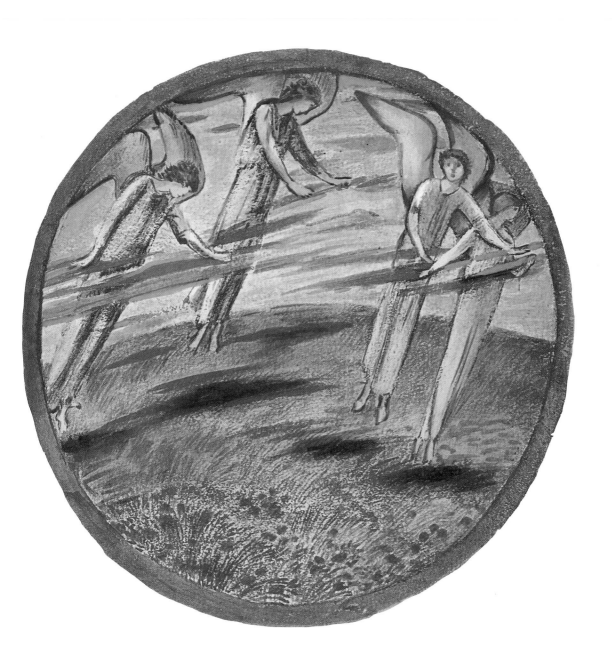

XXII. With the Wind

Dante's vision of Paolo and Francesca ❖

The writings of the Italian poet Dante Alighieri (1265–1321) provided a rich source of inspiration for the Pre-Raphaelite painters. *With the Wind* became, for Burne-Jones, a picture of *Dante's vision of Paolo and Francesca*. The forbidden love between these two young people, who were related by marriage, could only be purified by death. After a life of denial, the two lovers find deliverance in death. Paolo and Francesca are borne by the wind into another world where earthly conventions no longer apply ❖

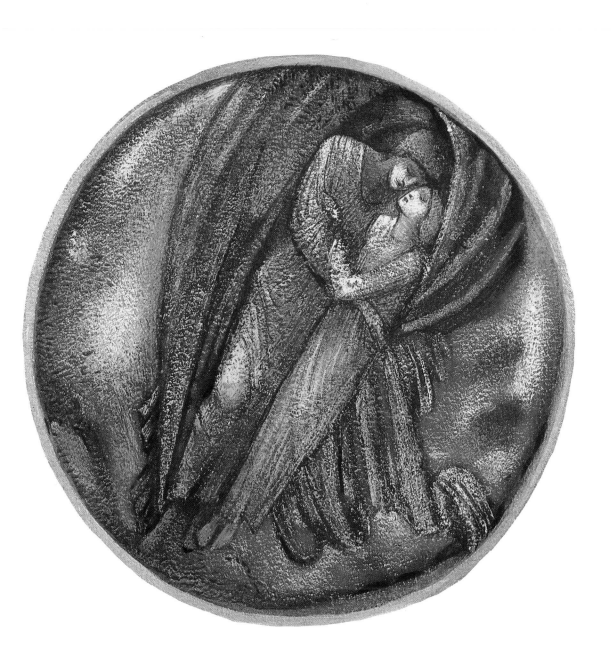

XXIII. Wake, Dearest!

The Sleeping Beauty ❖

Between 1870 and 1873 Edward Burne-Jones worked on a cycle entitled *The Briar Rose*, comprising three oil paintings whose subjects were drawn from the Sleeping Beauty fairytale. The artist subsequently embarked upon a second, more ambitious and larger-format series of four paintings on the same theme, which he completed in 1890. Both cycles conclude with a portrayal of Sleeping Beauty not yet aroused from her sleep by the Prince, in paintings entitled *The Sleeping Princess* in the first series, and *The Sleeping Beauty* in the second. Burne-Jones reserves the tender scene in which the Prince gently awakens Sleeping Beauty for one of his intimate flower pictures ❖

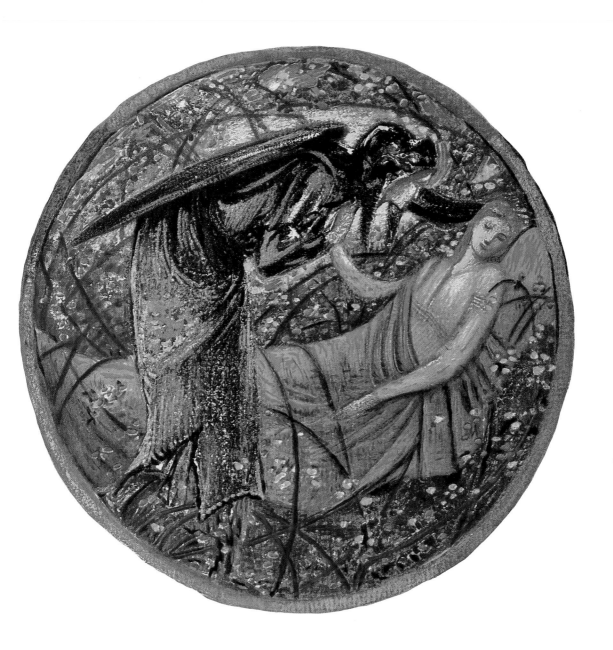

XXIV. Wall Tryst

Thisbe's letter to Pyramus ❖

In his subtitle to this flower picture, Burne-Jones refers us to the tale of a passionate love that was never to be fulfilled. The young Babylonian couple Pyramus and Thisbe had been forbidden to meet by their fathers. They were only able to swear their love for each other through a chink in the wall which separated their parents' houses. The tragic story of Pyramus and Thisbe is told in the 4th book of Ovid's *Metamorphoses*; it also surfaces in Shakespeare's *Midsummer Night's Dream* in the form of a burlesque performed by Bottom and his rustic friends, reinforcing the web of confusion surrounding love ❖

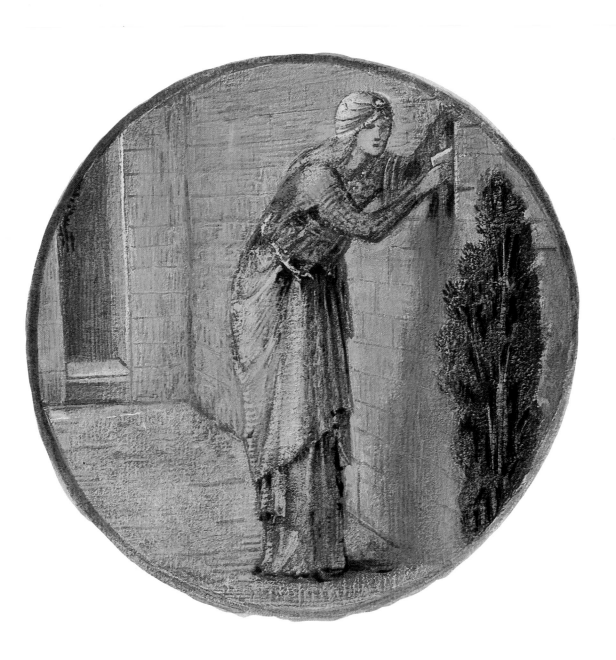

XXV. Helen's Tears

H elen weeps that Troy is burning ❖

Helen's Tears is a flower name which Burne-Jones links directly with the fall
of the city-state of Troy in antiquity. Helen, the beautiful daughter of Zeus
and Leda, was abducted by Paris and taken to Troy. Paris' action precipitated
a terrible war between the Trojans and the Greeks, ending in the destruction
of Troy and its people. Standing on the parapet of the city wall, Helen holds
her head in horror as if wanting to block out the sounds of the battle raging
around her, while flames from the burning city blaze wildly behind ❖

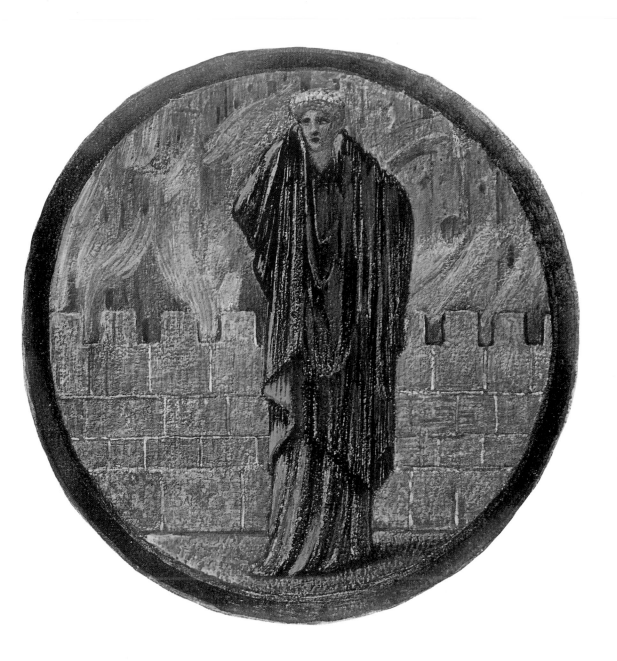

XXVI. Marvel of the World

Birth of Venus ❖

Venus, the goddess of love and beauty, has just sprung from the foaming waves. Although she has not yet set foot on earth, she is shown dressed. Coming from the "west", she is borne rightwards aross the water. In contrast to the relatively calm, unruffled surface of the sea in the foreground, the sky above the shoreline behind is filled with banks of billowing cloud. This suggestion of a storm that has just passed may be a hidden reference to the fact that the birth of Venus followed a violent battle between the Titans ❖

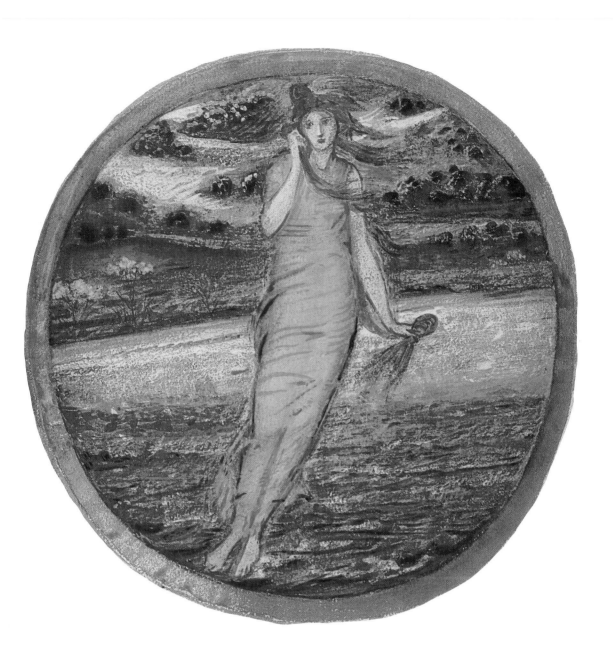

XXVII. Black Archangel

*S*atan enthroned ❖

In the Old Testament, the beauty of the most magnificent of all the archangels is described as the reflection of divine light. Lucifer's arrogant desire not simply to be a reflection of God, but to be His equal, brings about his fall. Crystalline clarity now gives way to heavy darkness. Vitalizing light has become consuming fire. His power is an illusion, for he lacks the celestial companions whom once he headed. Lucifer becomes Satan enthroned in Hell ❖

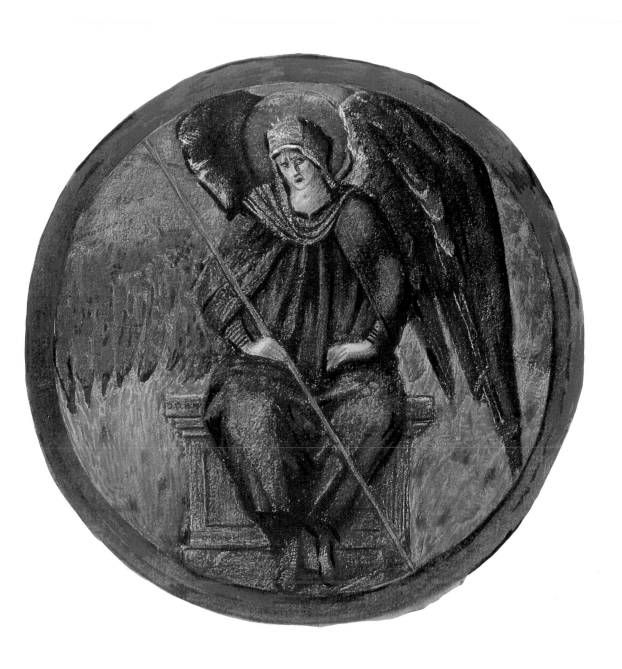

XXVIII. Arbor Tristis

The foot of the Cross ❖

Arbor Tristis is the only one of the flower pictures to contain no figures. The foot of the Cross is the tree-trunk in the centre of the composition: pegged into the spiralling layers of a rocky hilltop, it rises out of the picture into an imaginary zone beyond. Behind the rood tree, a dark semicircle of buildings is silhouetted against the horizon. The walls are interrupted by flecks of orange and yellow, like eyes flashing with menace as they watch the scene. Burne-Jones leaves it to the imagination of the viewer to visualize the person who is crucified here ❖

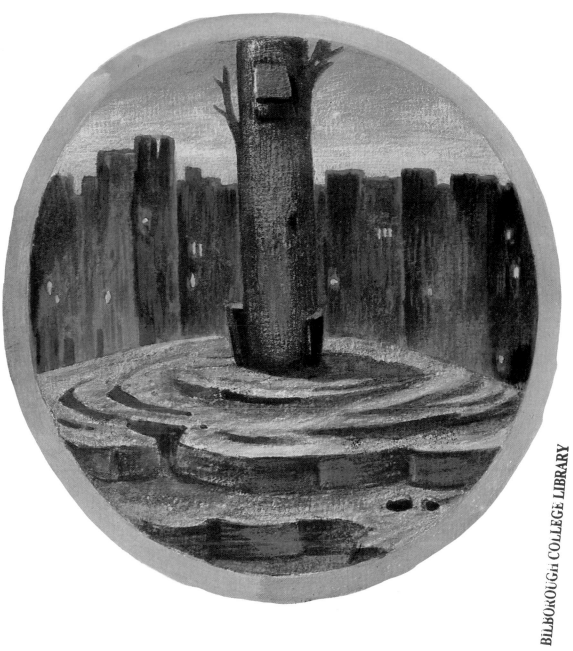

73

XXIX. Scattered Starwort

Angels casting stars through the sky like seed ❖

The theme of angels strewing stars was one that Burne-Jones treated on several occasions, both in his large-format works and in drawings and sketches. Here, the entire surface of the picture is filled by a line of angels in harmonious proportion, wafting gracefully through the deep blue heavens. The procession in which the celestial figures are depicted suggests a passing vision inside a magic crystal ball ❖

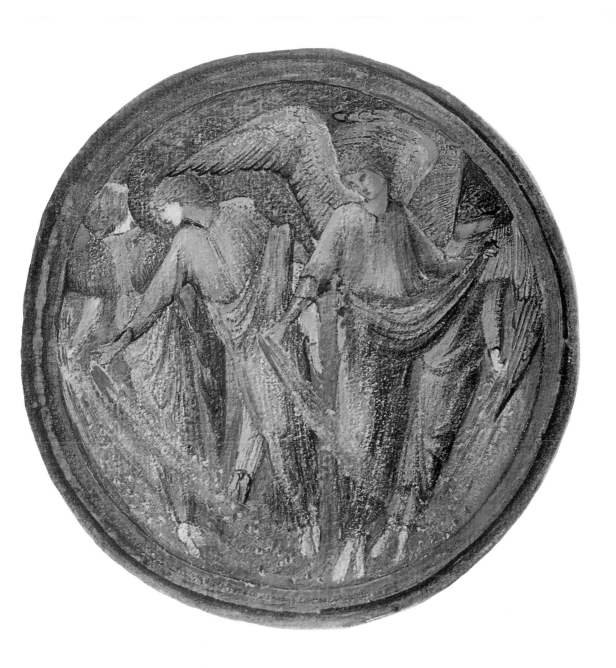

XXX. Saturn's Loathing

A thing the most repugnant to the Earth-god; armed men joining battle in a cornfield and trampling the ripe grain under their horses' hoofs ❖

As in *Love in a Mist* (I), Burne-Jones attaches a lengthy subtitle to the flower picture *Saturn's Loathing*. In associating Saturn with the god of fertility and the earth, he is referring to a Greek myth of creation from pre-classical times ❖

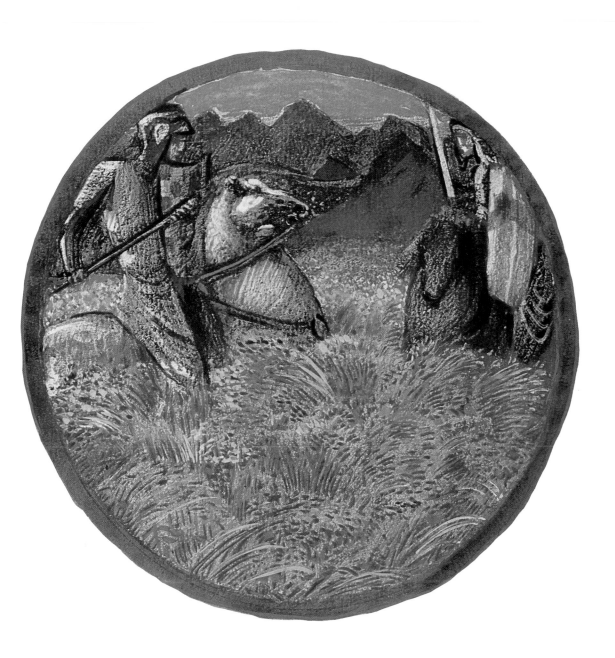

XXXI. Welcome to the House

A soul received at Heaven's gate ❖

An angel with mighty wings and a halo reaches down towards a small figure who has just arrived at the gates of Heaven, in order to receive it into the celestial dimension. The strict verticality of the line delimiting the heavenly portal from the abstract space beyond is softened by the two figures, who overlap the two spheres as they lean towards each other ❖

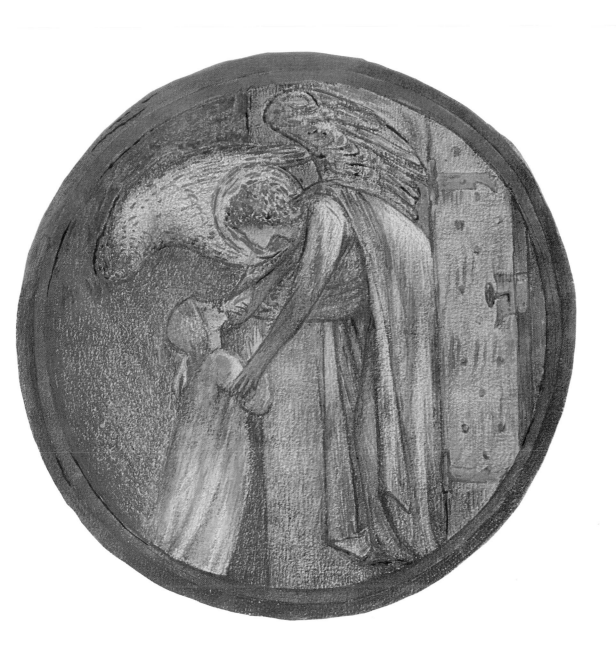

XXXII. Honour's Prize

A Knight following the Vision of the San Graal ❖

Rocks, traditional symbols of freedom from greed and lustful desire, form the backdrop to this meeting between a young knight and a figural vision of the Holy Grail. In contrast to his sleeping counterparts in *Golden Cup* (VII), the knight in *Honour's Prize* is fully alert as he concentrates upon attaining mystical enlightenment. He has chosen an arduous path, symbolized by the jagged, densely-clustered rocks. The hermetic nature of the setting is a further indication that the artist wishes us to understand the landscape in symbolic rather than naturalistic terms: the path to mystical enlightenment passes through asceticism ❖

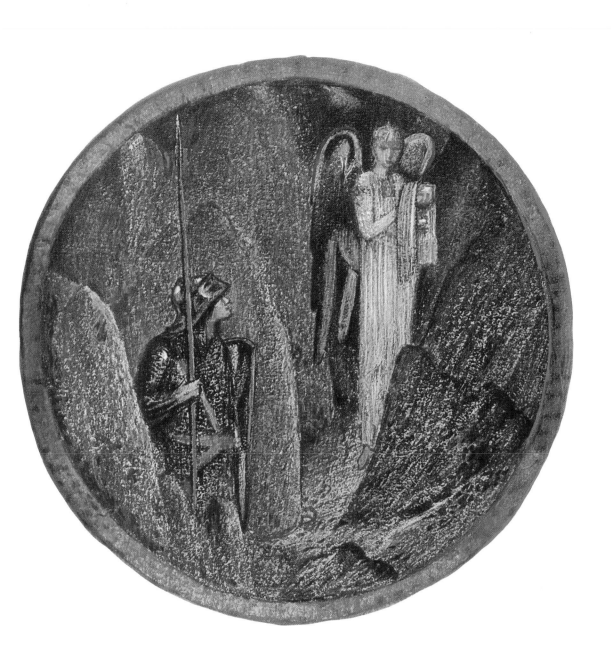

XXXIII. Most bitter Moonseed

The enemy sowing tares by night ❖

The dark-clad, winged figure of the "enemy" is walking towards the front of
the picture, his body angled slightly to the left and his eyes raised to the
viewer, scattering his "most bitter" seeds as he goes. The sense of his
inexorable approach is heightened by the curving lines of perspective
describing his path: from an invisible point in the middle of the picture, they
fan outwards towards the foreground. In contrast to Venus in *Venus' Looking
Glass* (X), who becomes a projection of beautiful dreams, the "enemy" is here
infused with a romantic longing and sadness ❖

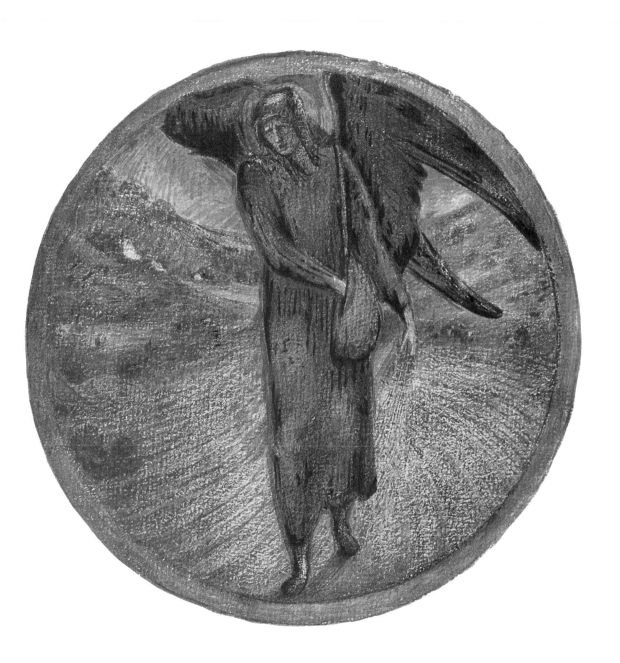

XXXIV. White Garden

The Annunciation in a garden of lilies ❖

Transported to a small clearing in a field of white Madonna lilies dotted with flecks of blue, the viewer witnesses the moment in which the Archangel Gabriel announces to Mary that she is to bear the Son of God. The thickly-blooming lilies fill the background, turning the clearing into a *hortus conclusus*, an enclosed, protective garden. As in *Flower of God* (VI), Burne-Jones places the Annunciation in a natural setting. In puritanical Victorian England, the theme of "conception without sin" was one to which the Pre-Raphaelites were inevitably drawn ❖

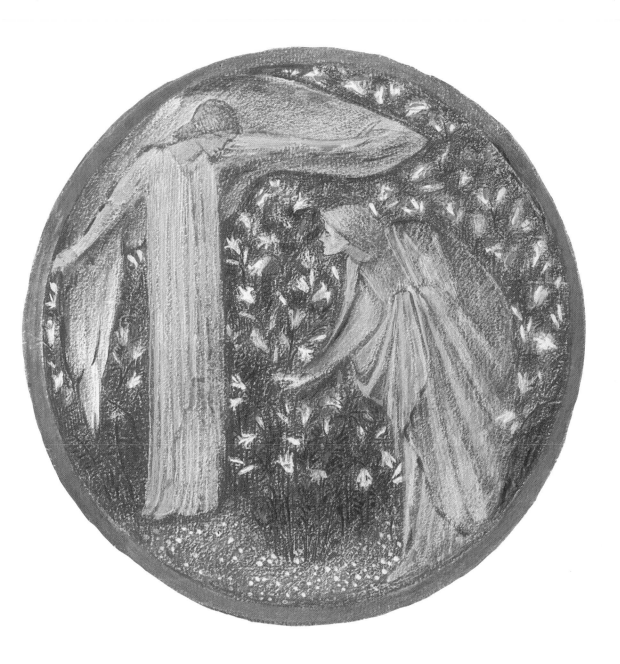

85

XXXV. Meadow Sweet

Arthur's rest in the valley of Avalon ❖

Burne-Jones' fascination with the Arthurian legends found its last expression in his large-format *Arthur in Avalon*, a complex work which occupied him during the last ten years of his life. In *Meadow Sweet* he treats the same subject, but using a more intimate, reserved pictorial language. King Arthur is seen slumbering in the magical land of Avalon until, at some point in the distant future, his ship of life is made ready again and he is called to perform new deeds. He is watched over in his sleep by fairies playing music, who belong to the entourage of Arthur's half-sister Morgaine ❖

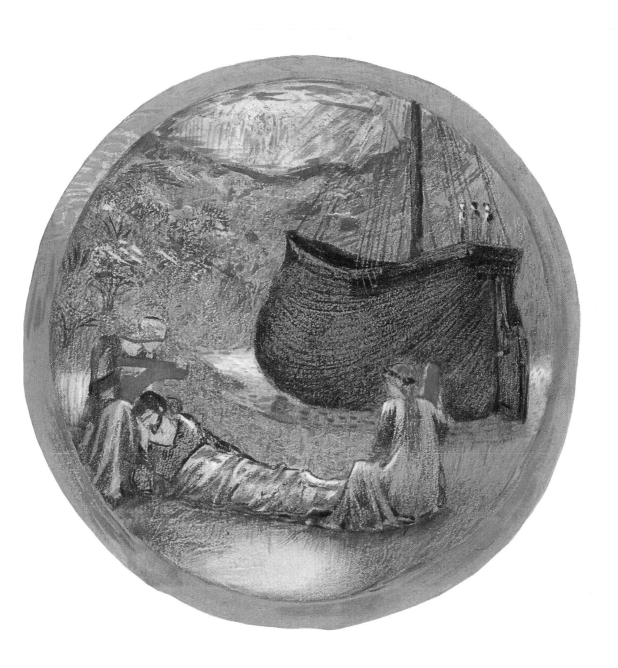

XXXVI. False Mercury

The Dream-god shewing happy dreams of home to sleeping mariners at sea

❖

Mercury, the Roman counterpart of the Greek god Hermes, was Jupiter's messenger and the god of dreams and science. He was also, however, the patron of thieves and tricksters. It was up to those who received his messages to decide what was true and what false. In *False Mercury*, Burne-Jones personifies the lonely sailors' yearnings in the figure of Mercury. The mariners have clearly fallen into distress and are drifting in a lifeboat on the open sea. Like a conjurer, Mercury lets the wisps of the mariners' happy dreams of home shimmer in his two crystal balls ❖

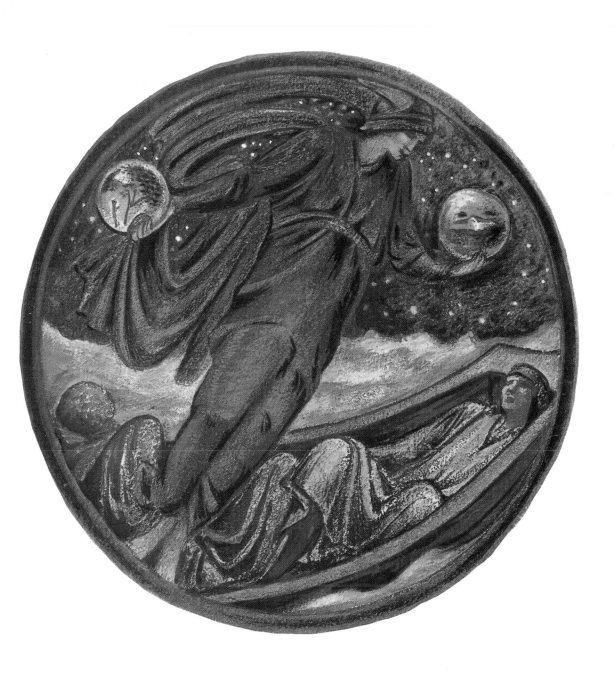

XXXVII. Fire Tree

Moses at the burning bush ❖

The subtitle to this flower picture refers us to an event which is recounted in the 2nd Book of Moses, Exodus 3:2–5: "And the angel of the Lord appeared unto him in a flame of fire out of the midst of a bush. And he looked, and, behold, the bush burned with fire, and the bush was not consumed… And when the Lord saw that he turned aside to see, God called unto him out of the midst of the bush, and said, Moses, Moses. And he said, Here am I. And he said, Draw not nigh hither. Put off thy shoes from off thy feet, for the place whereon thou standest is holy ground." ❖

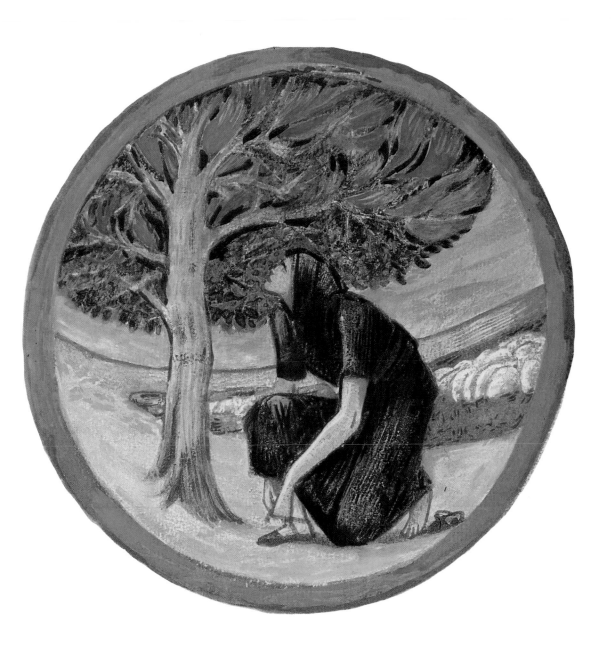

XXXVIII. Day and Night

Night, in the form of a woman heavily draped, calls on Day to awake from his sleep and set her free ❖

The lingering moment in which night is still visible through the gradual dawning of day, while day begins to take shape amidst the vanishing darkness of night, is the theme of *Day and Night*. The rhythm of day and night involves the awakening of one to replace the other. In this treatment of dawn, a traditional subject in western painting, Burne-Jones personifies Night as a woman and Day as a man ❖

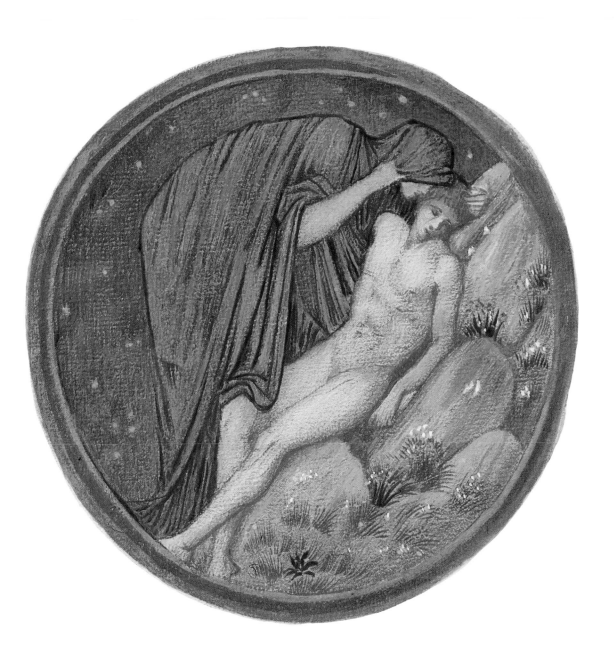

Edward Burne-Jones
Life and Work

George Howard:
Portrait of Edward Burne-Jones,
c. 1875
National Portrait Gallery, London
Photo: Lewis Carroll

Edward Burne-Jones was born on **28 August 1833** in the industrial city of Birmingham, where his father ran a modest framing and gilding business. His mother died just six days after his birth. The sickly young Burne-Jones, only partially accepted by his father, increasingly sought escape in the world of his drawings. "Unmothered, with a sad papa, without sister or brother, always alone, I was never unhappy, because I was always drawing." In **1844** he became a pupil at King Edward's School in Birmingham. His childhood was punctuated by traumatic events. The depressed areas of Birmingham also made an enduring impression upon him. A strikingly intelligent and serious student, he also revealed a great sense of humour, particularly in the caricatures which he sketched of his teachers. He went on to attend classes at the Government School of Design, after which his father gradually came to take his artistic ambitions more seriously, no longer insisting that he should train as an engineer. Following a visit to the Cistercian monastery of Mount St Bernard in rural Leicestershire in **1850**, Burne-Jones felt called to a life of monastic seclusion. In **1853** he started studying theology at Exeter College in Oxford. It was here that he struck up what would become a lifelong friendship with fellow student William Morris. Together, the two young men read medieval romances and the works of John Keats, Samuel T. Coleridge, Thomas Carlyle and John Ruskin. Burne-Jones' favourite poet was Chaucer, whose works William Morris would later publish through the Kelmscott Press, which he founded in **1890**. Burne-Jones produced 83 drawings for the Kelmscott Chaucer between **1891** and **1896**. Alongside their reading of the myths of classical antiquity, Burne-Jones and Morris were influenced above all by *Le Morte Darthur* by Sir Thomas Malory, a 15th-century compendium of Arthurian legends which became a major source of inspiration for Burne-Jones' painting. In **1855** Morris and Burne-Jones took a trip to Paris, where they were profoundly impressed by Fra Angelico's *Coronation of the Virgin* in the Louvre. Back in Oxford, Burne-Jones saw his first pictures by the Pre-Raphaelite Brotherhood, and travelled to London to visit Ros-

setti, the leading member of the group. The Brotherhood had disbanded in 1854, but Rossetti continued to champion the ideal of honesty in art. In **1857** Burne-Jones, together with Morris, broke off his theology studies for good, and went to London to become an artist. Also in **1857**, having been recommended by Rossetti, Burne-Jones designed a stained-glass window for Bradford College in Oxford. He made his first trip to Italy that same year, and his art immediately reflected the influences he encountered there. In **1862** he went to Italy a second time, in the company of the art critic John Ruskin. One year earlier, Morris, the engineer Marshall, the mathematician Charles Faulkner, the architect Philip Webb and the painters Madox Brown, Burne-Jones and Rossetti had founded the firm of Morris, Marshall, Faulkner & Co, whose aim was to promote aesthetic design in objects of everyday use. In **1875** the partnership dissolved and Morris remained sole proprietor. Fresh trips to Italy heightened Burne-Jones' admiration for the Italian masters. In **1875** Burne-Jones was commissioned by Arthur James Balfour, the later prime minister, to decorate the reception room of his London residence. Burne-Jones decided to take his material from the legendary life of Perseus, which he had already treated in woodcuts. It was to be twenty years before the commission was finally completed, however. On **1 May 1877** the Grosvenor Gallery opened in London, with works by Whistler and Burne-Jones as its chief attractions. Still an outsider, Burne-Jones' *The Beguiling of Merlin* and *Days of Creation* now established his firm reputation. His "strange mixture of Gothic spirituality and classical grace in the respectable dress of the Early Renaissance" became the distinctive characteristic of his style. Exhibitions at home and abroad now followed. In **1882** he began work on his *Flower Pictures*, most of which were painted in Rottingdean. In **1885** Burne-Jones became a member of the Royal Academy, but resigned soon afterwards. His reputation reached its peak in **1890** with the exhibition at Agnew's of *The Briar Rose*, which was received with tremendous acclaim by critics and public alike. In **1894** the artist was given a baronetcy. For the company owned by his friend William Morris, he produced designs for over a hundred glass paintings, tapestries, tiles, ceramics and decorations for furniture. Burne-Jones did not live to see the execution of his designs for a tapestry entitled *The Briar Rose*. He died in London on **17 June 1898**.

Margaret, Edward, Phillip, Georgiana Burne-Jones, May Morris, 1874 (from l. to r.)